Pastel Punch

Stevan

40 Pastel Paintings On Paper

Cover: Shock and Awe

Copyright © 2012

Stevan CS

S

Dreaming

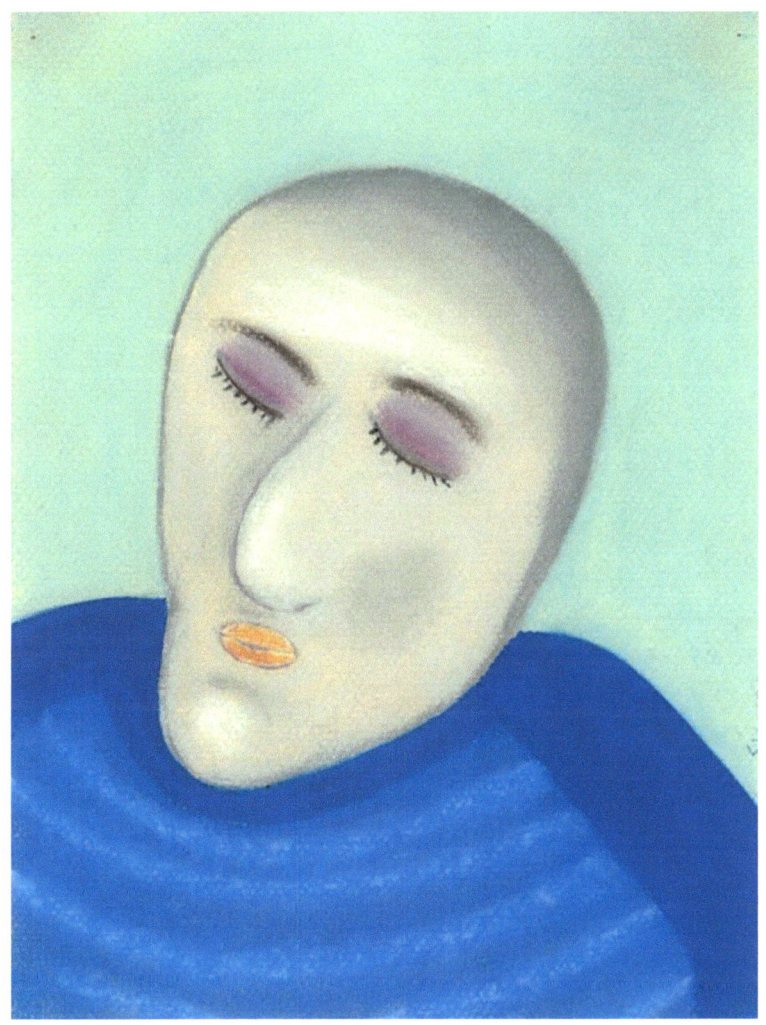

S

Hungry

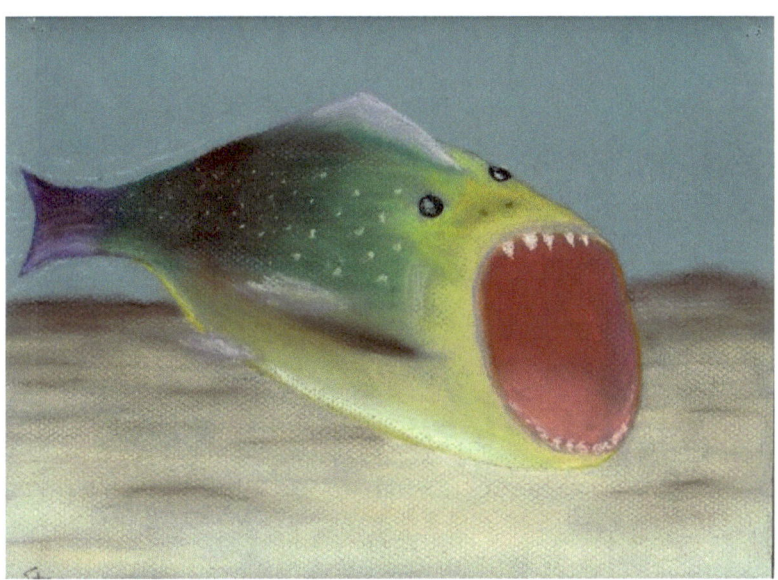

S

Mr. Green

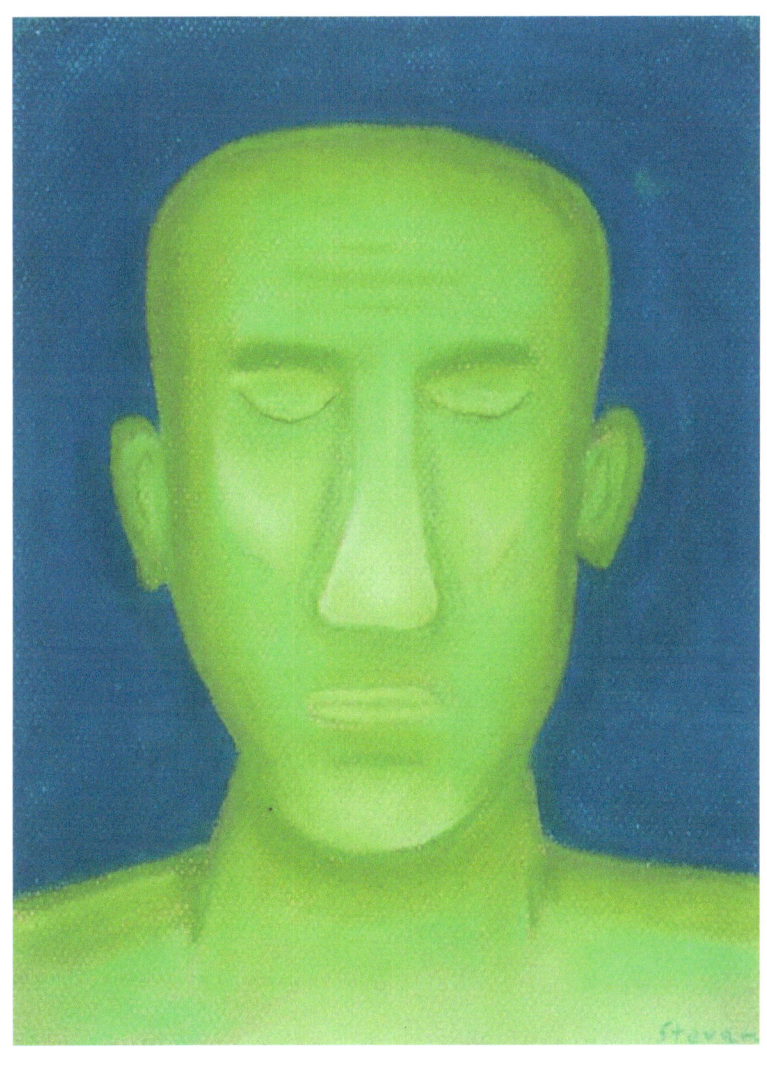

S

Hermaphrodite

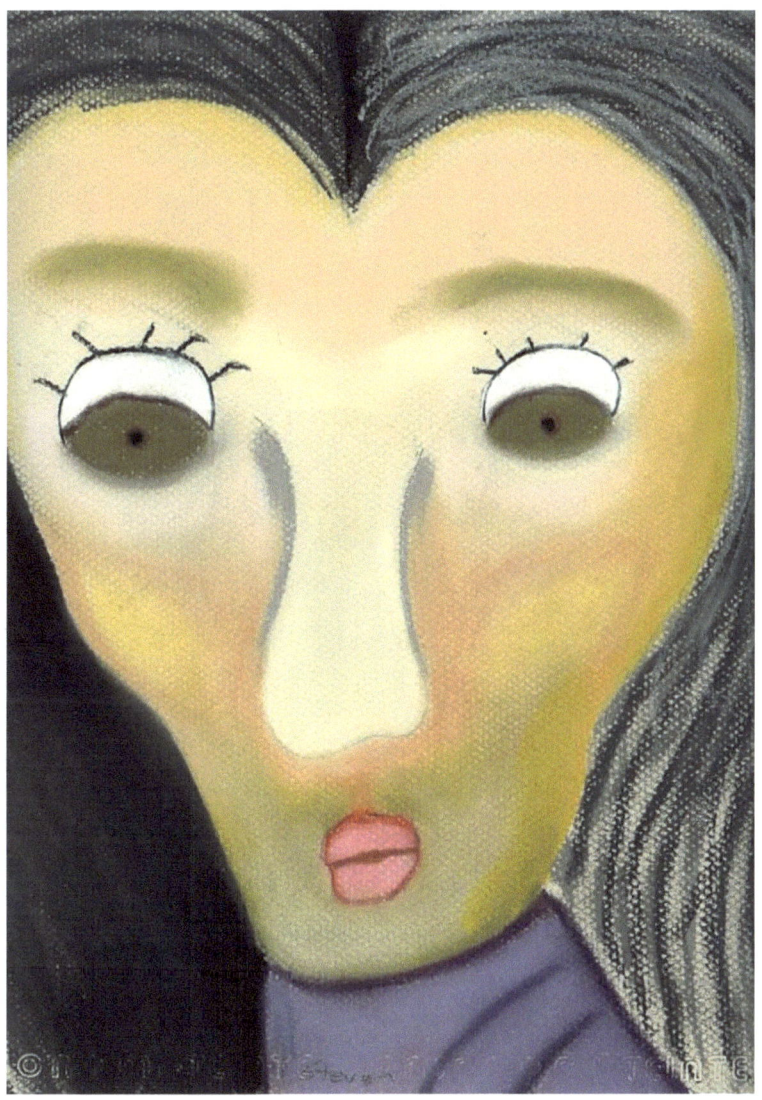

S

Controversy

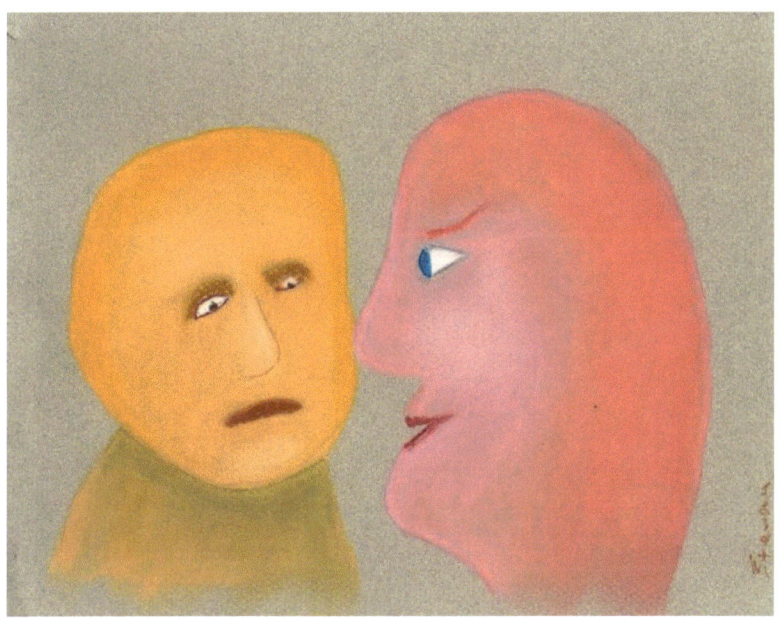

S

Joe Normal

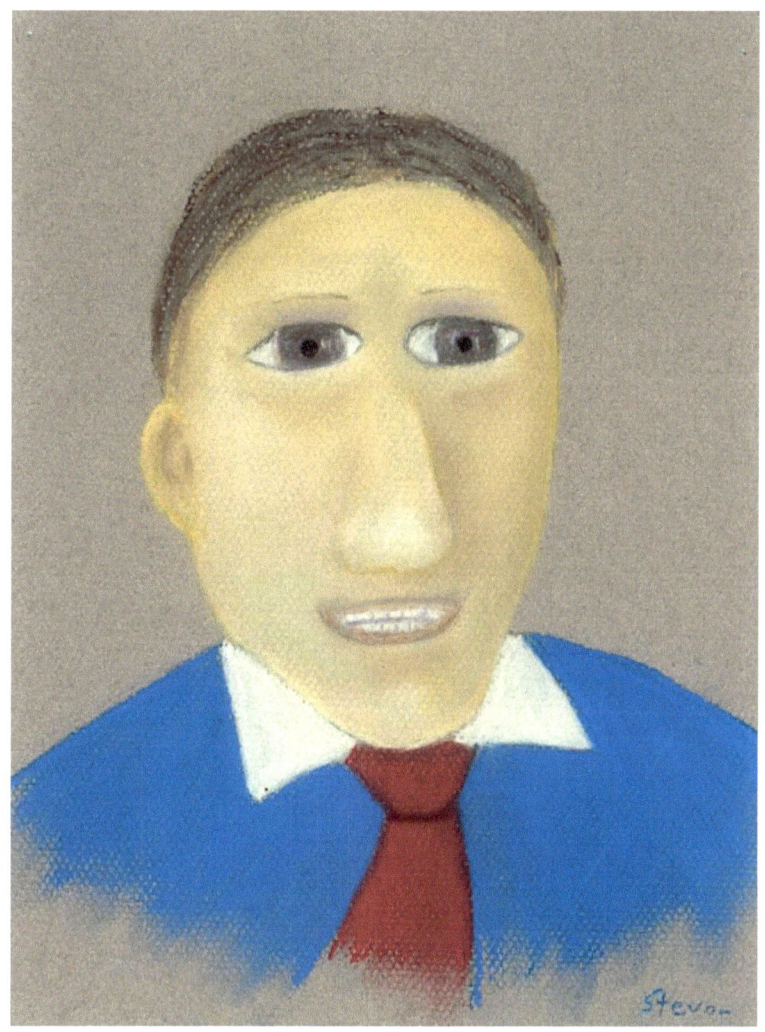

S

Mt. Olympus

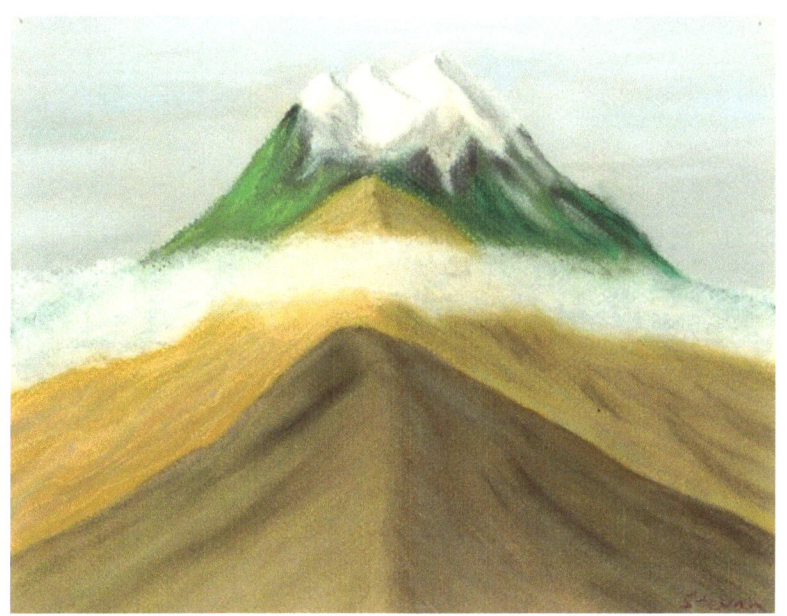

S

The Kiss

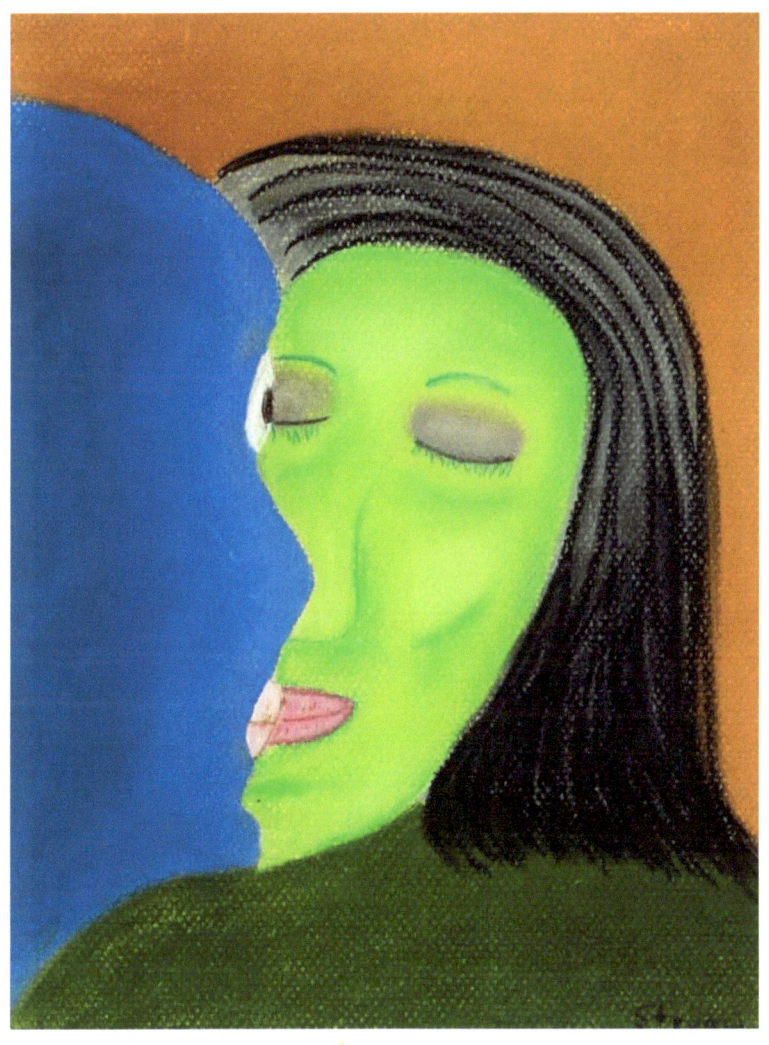

S

The Deep

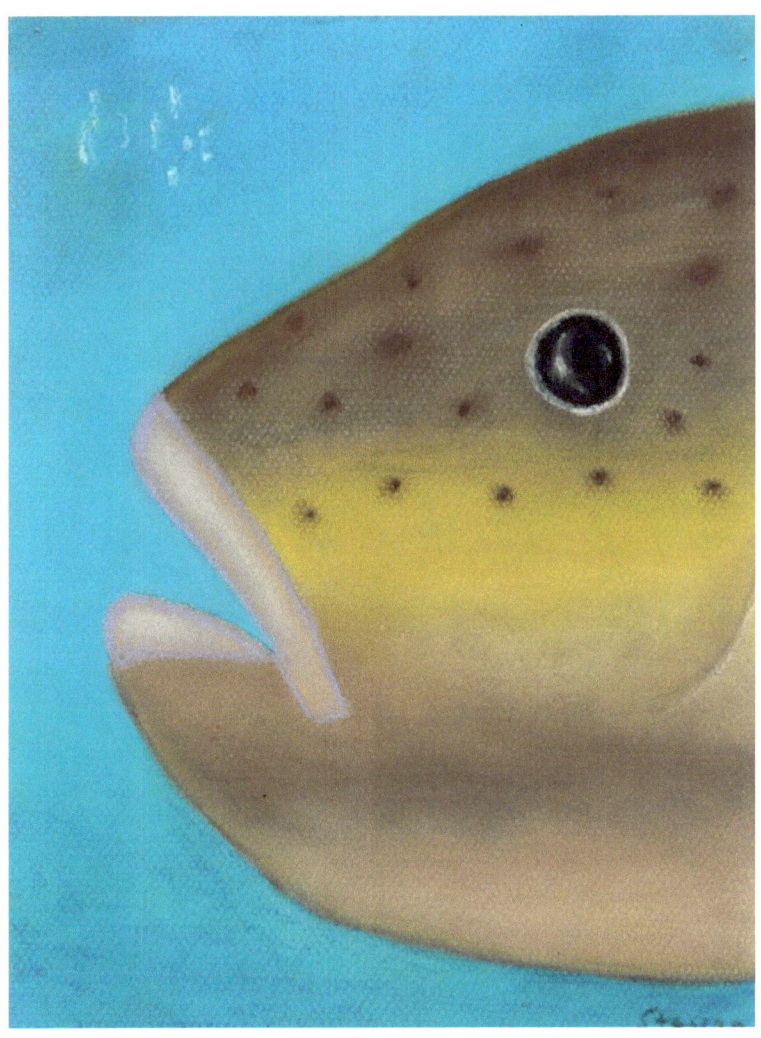

S

Coming Home

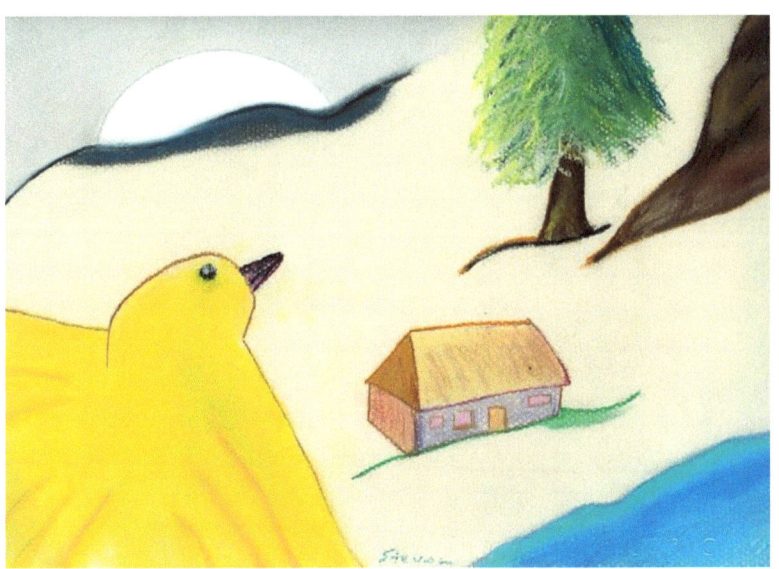

S

Beautiful Balloon

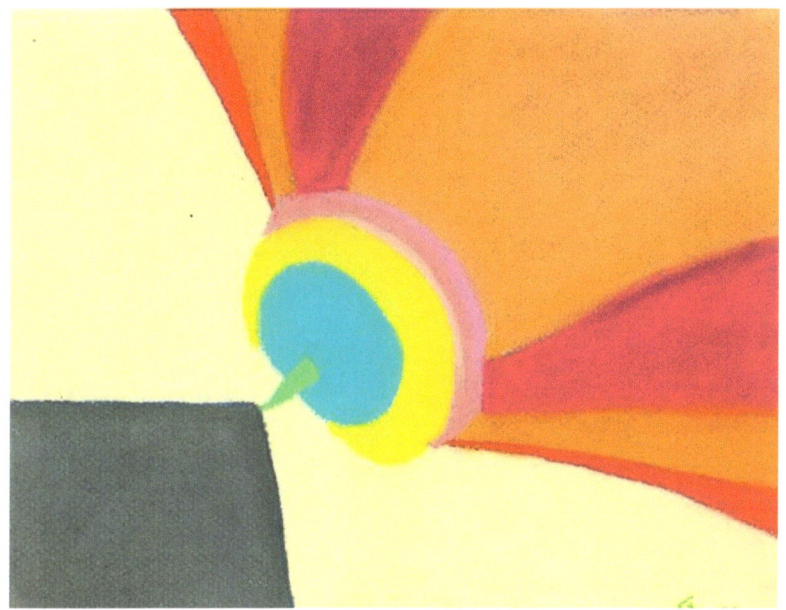

S

Lionman

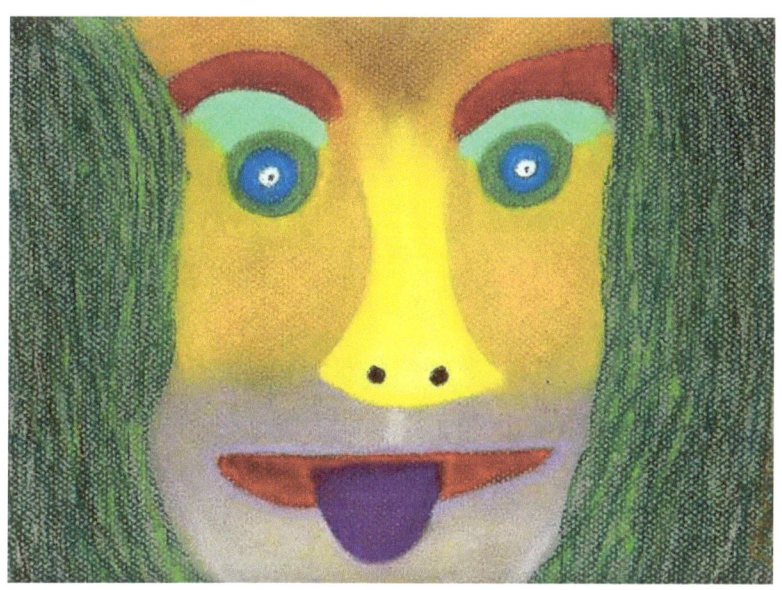

S

Reality

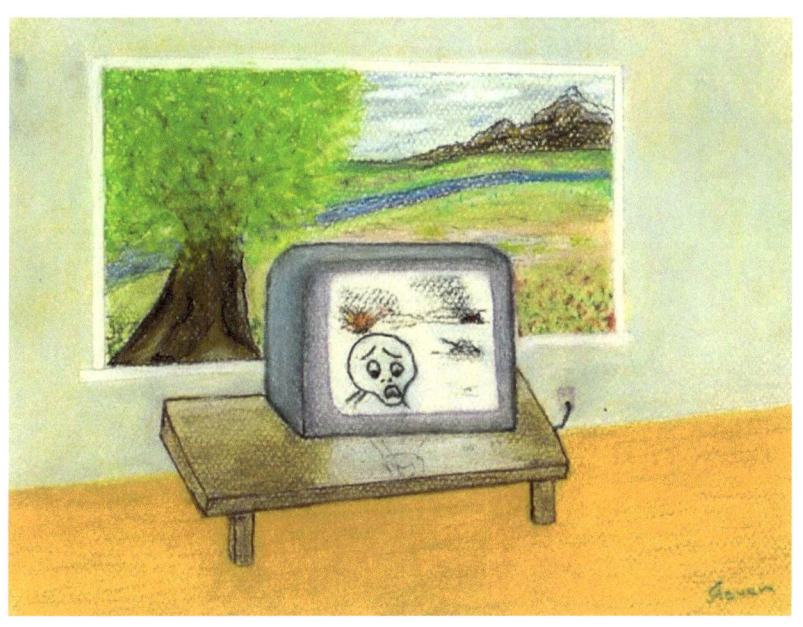

S

Determined

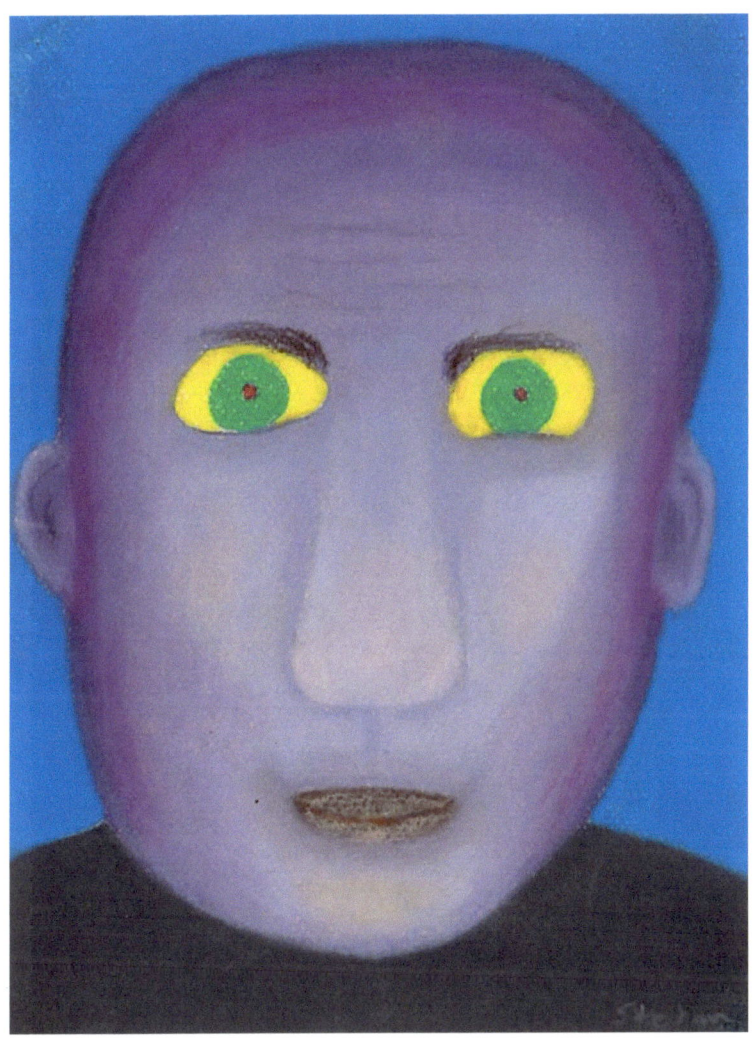

S

Seagull View

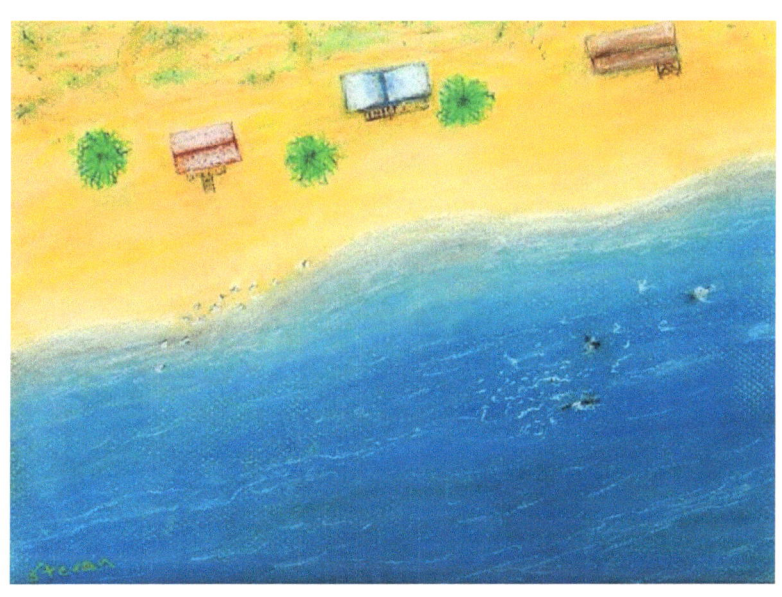

S

Harlequin

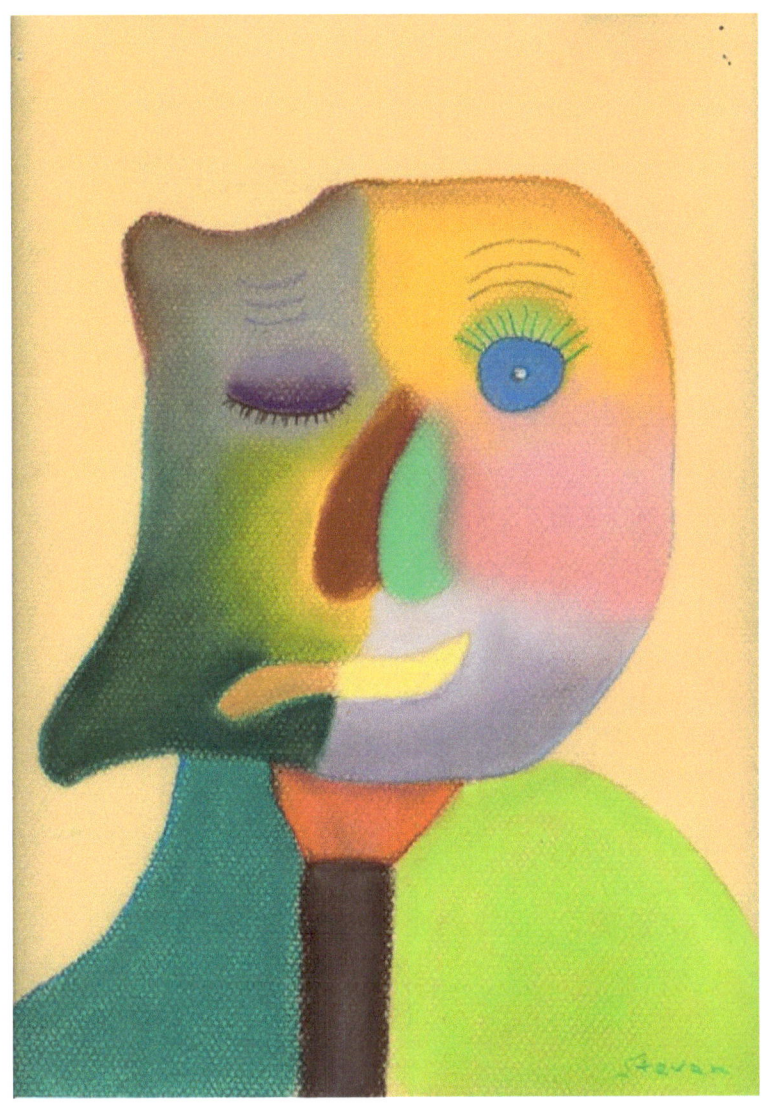

S

Progress

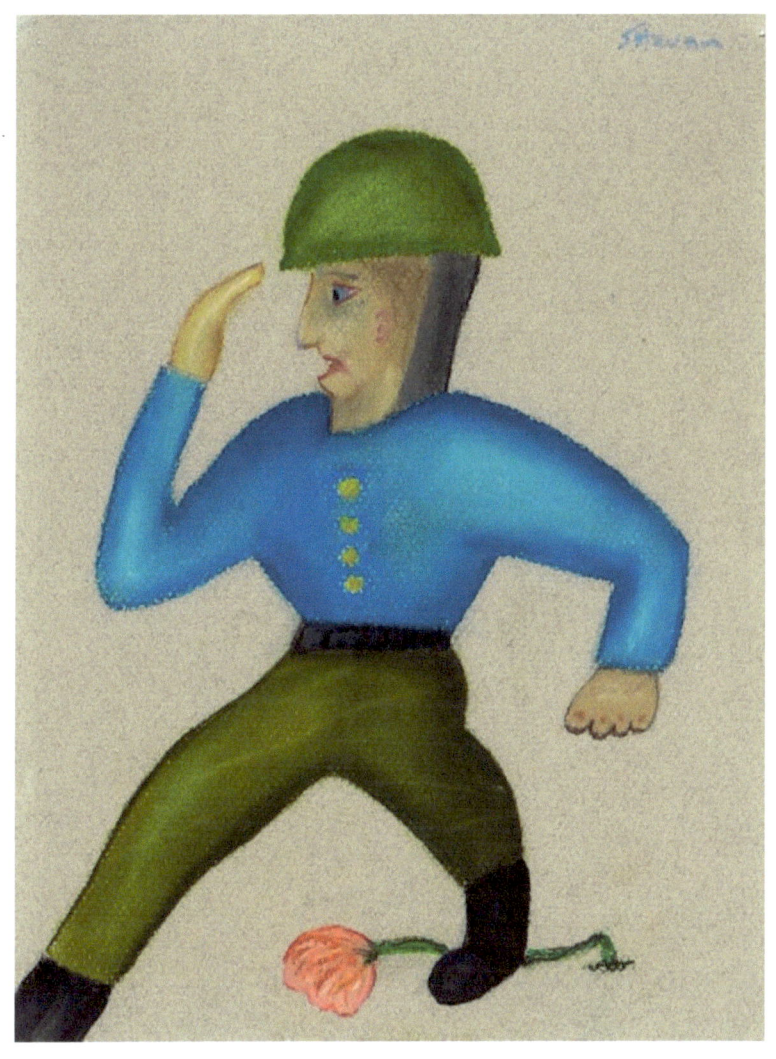

S

Astonished

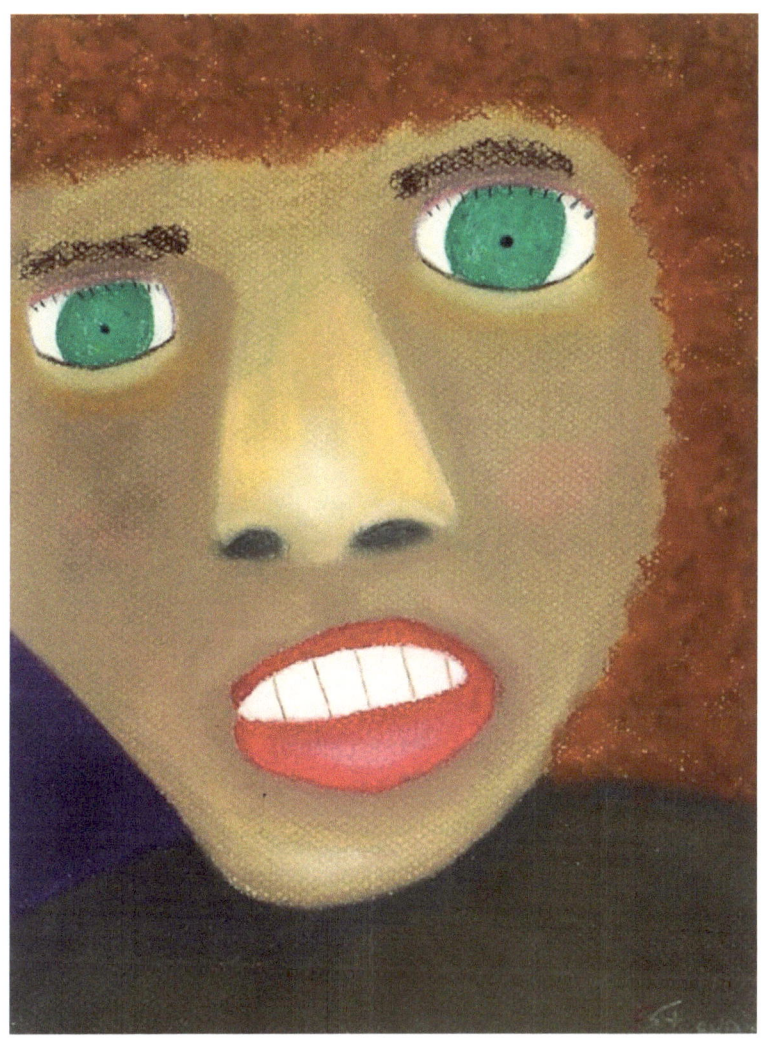

S

Water

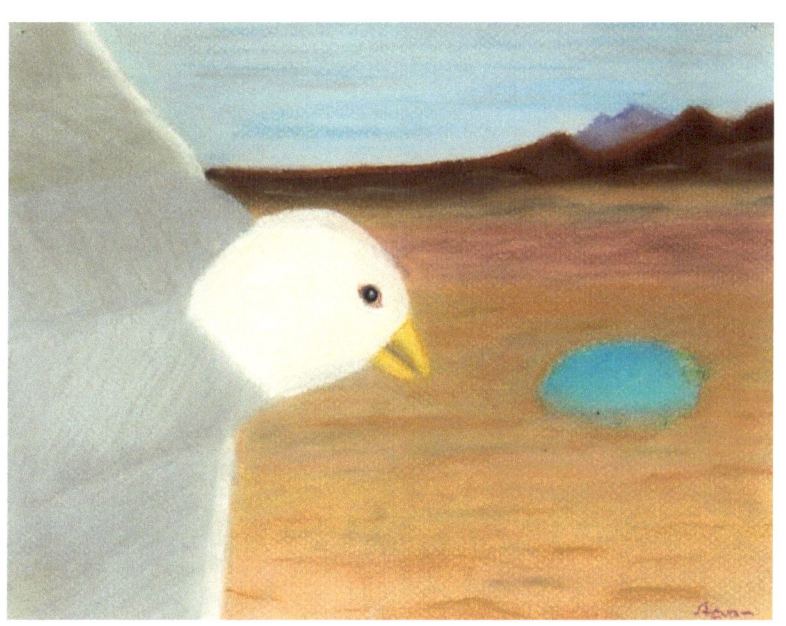

S

Nude

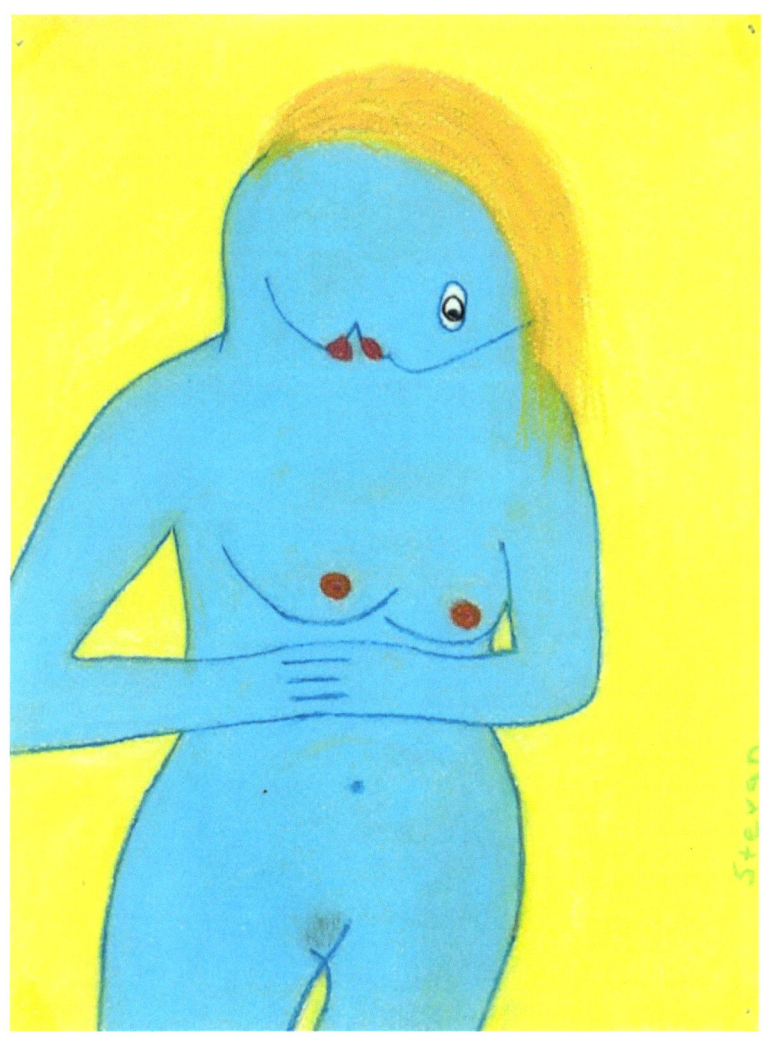

S

Foreign Land

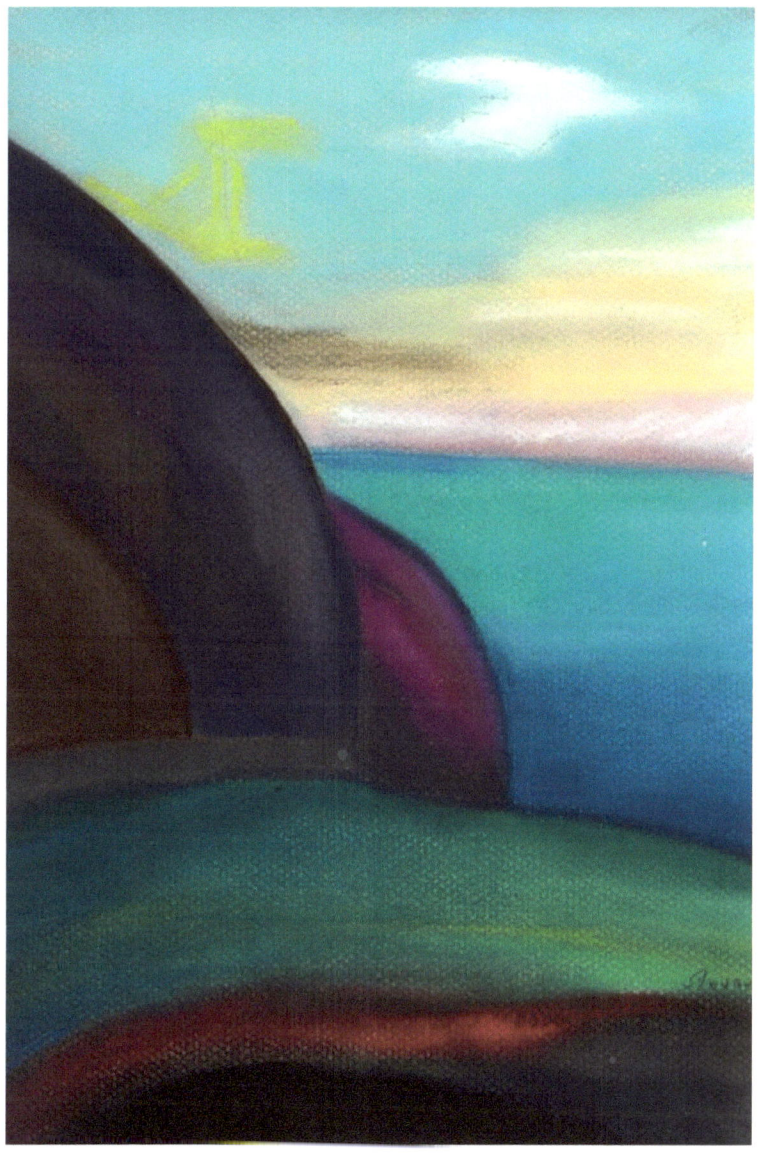

S

Little Boy Blue

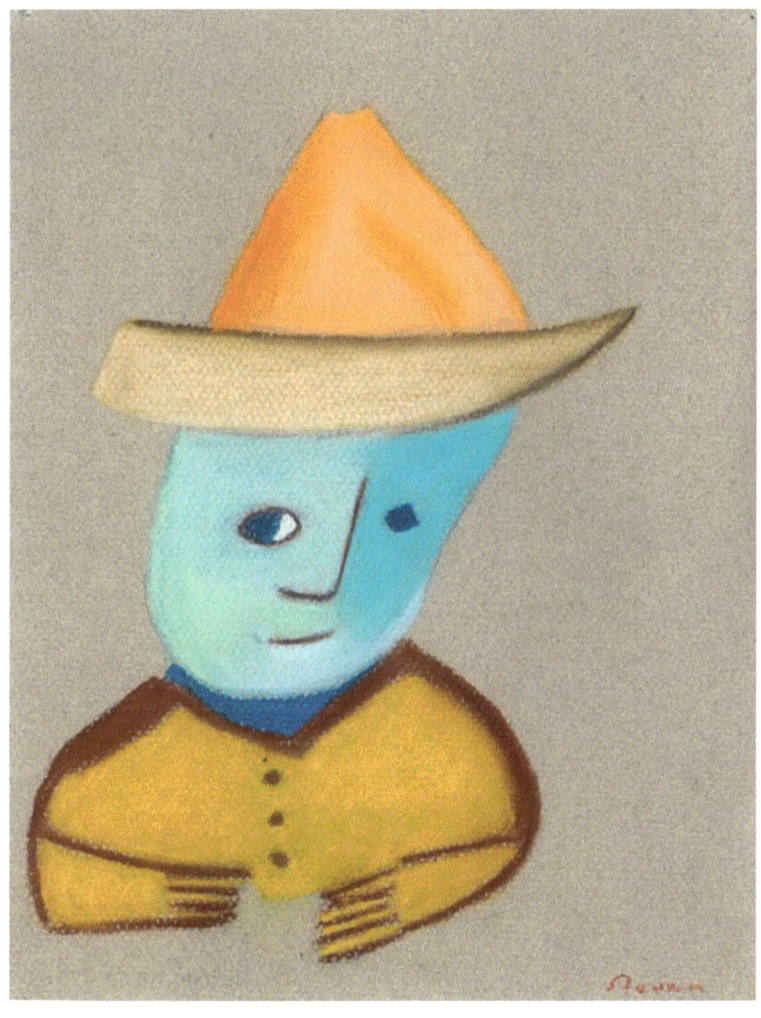

S

Pitcher

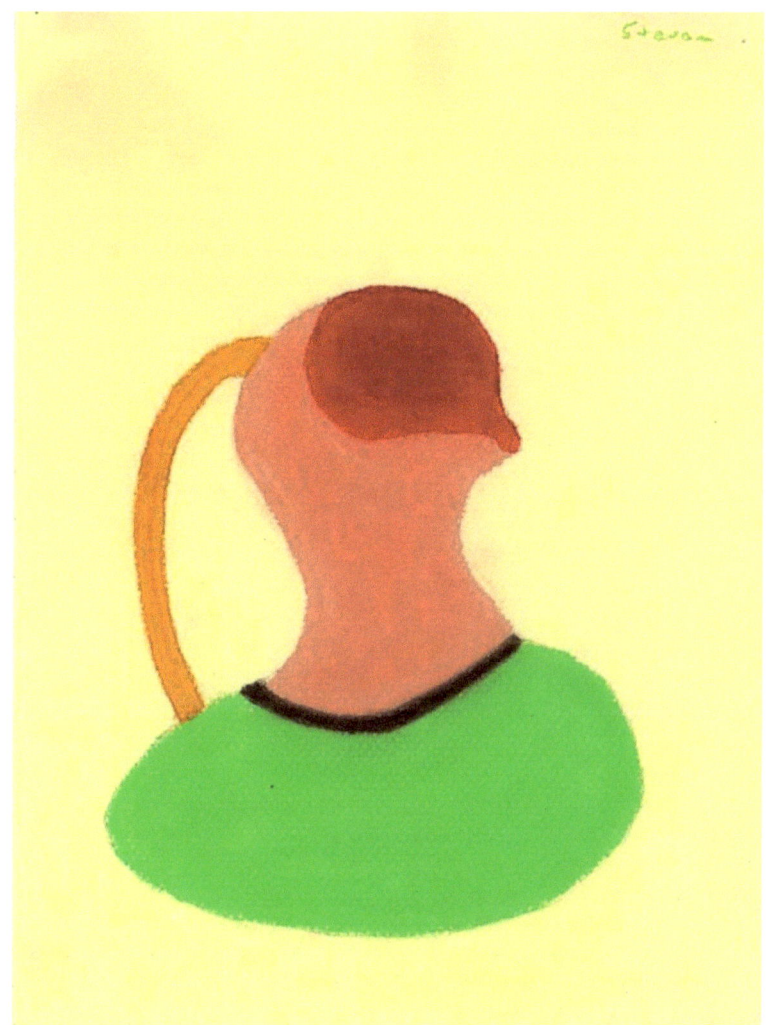

S

New Day

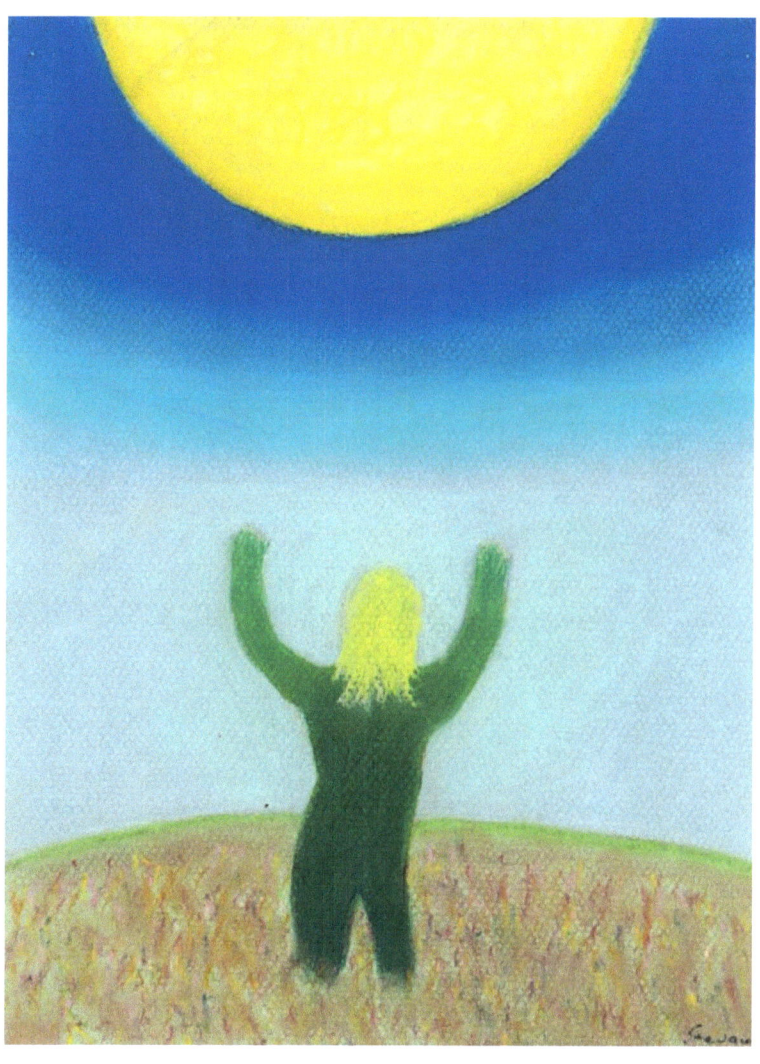

S

Ovum

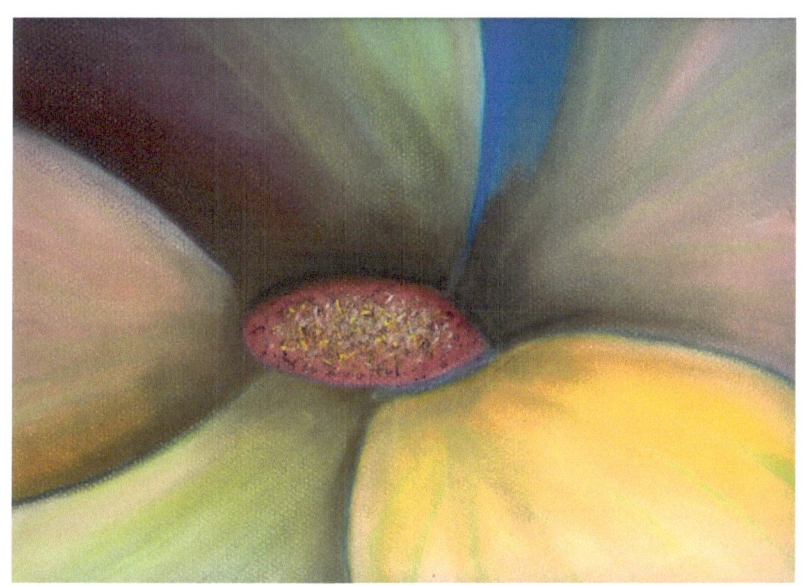

S

Death Mask

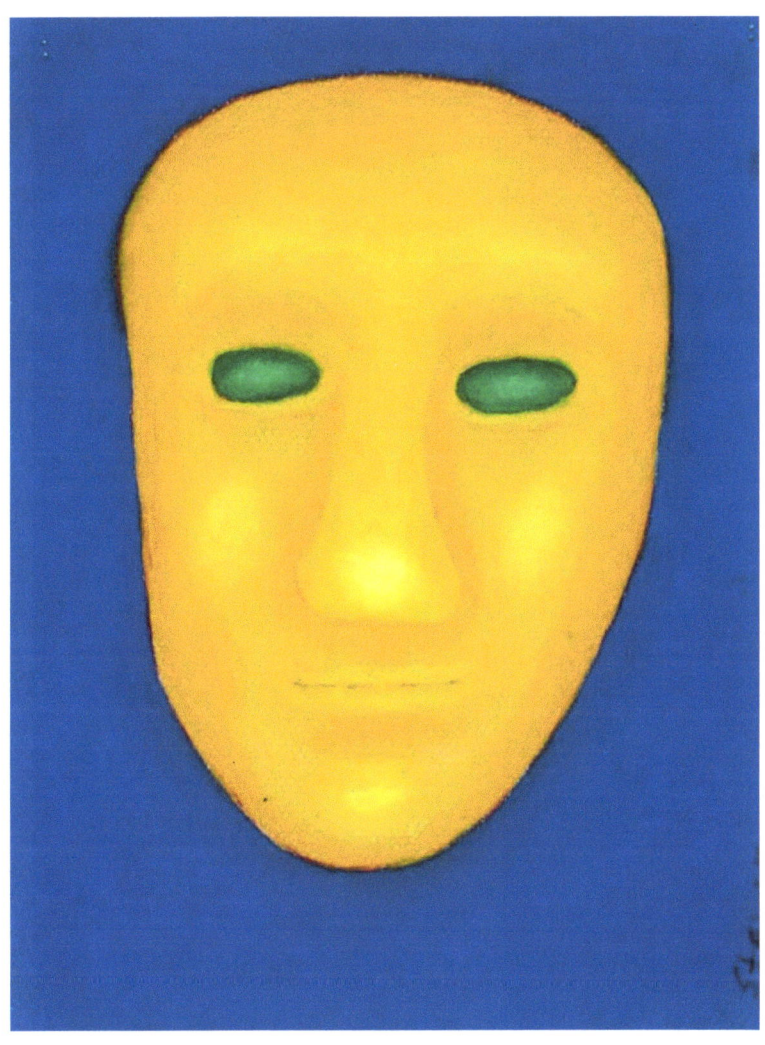

S

Liquid

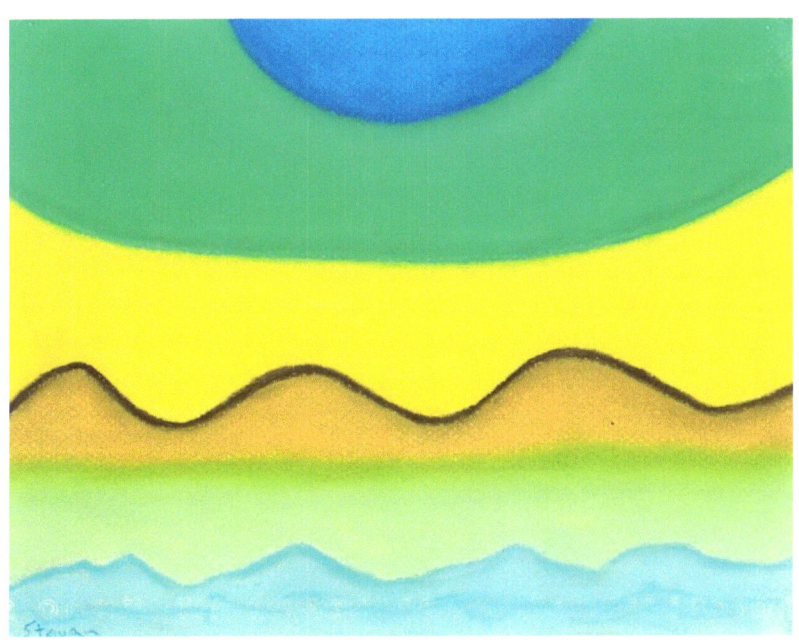

S

Office Manager

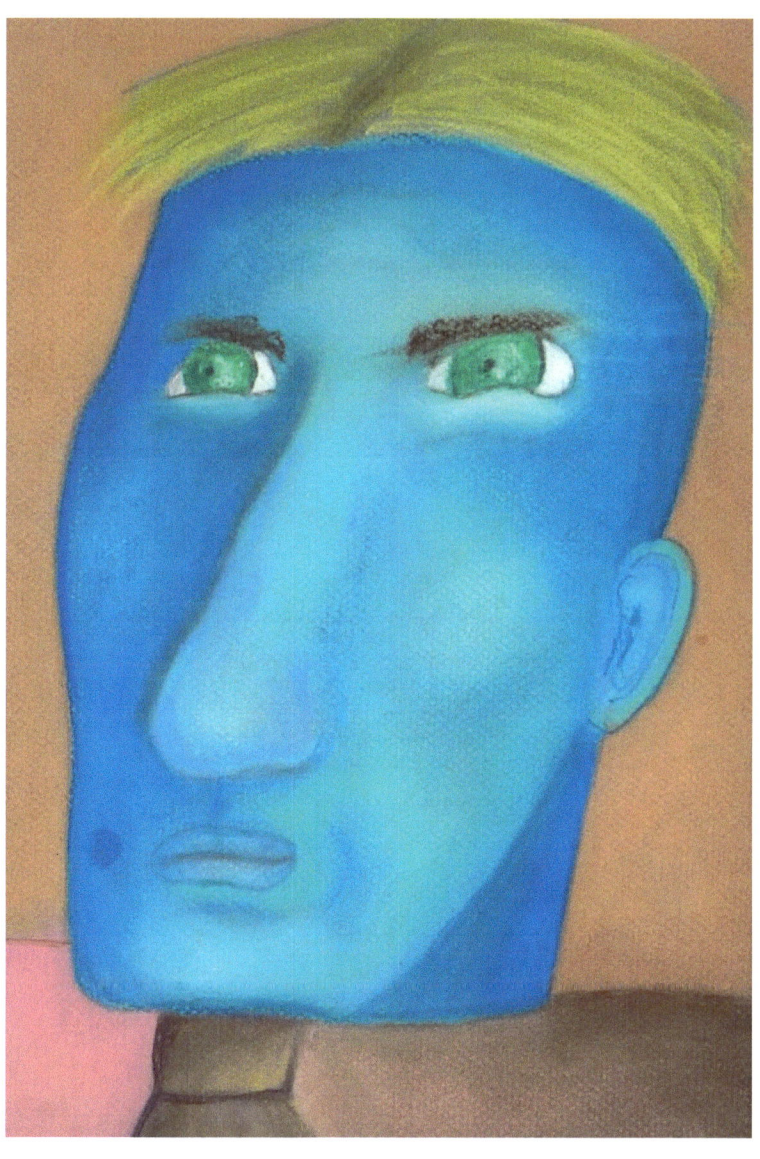

S

Pussywillow

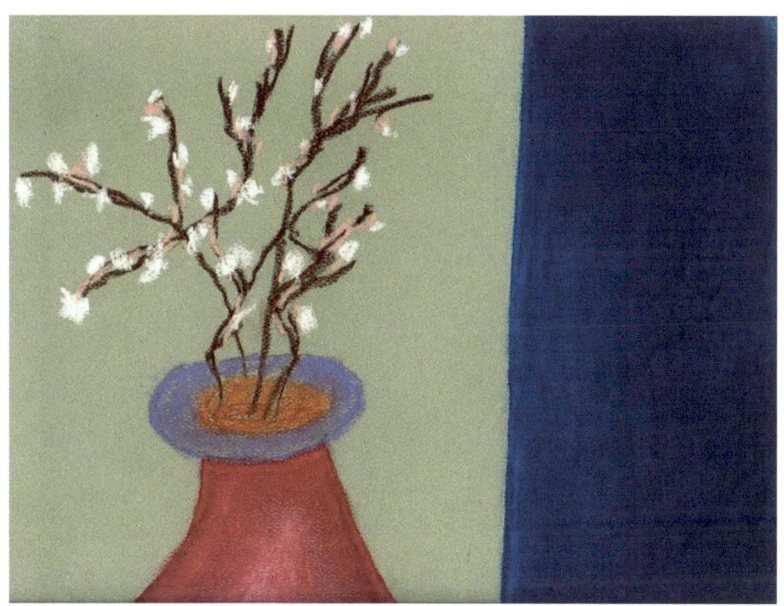

S

Moonlight

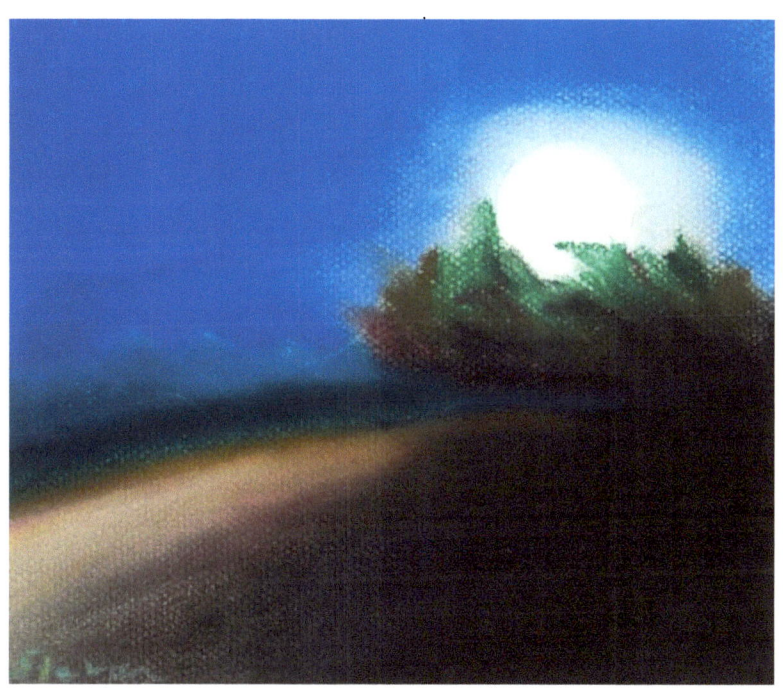

S

Love

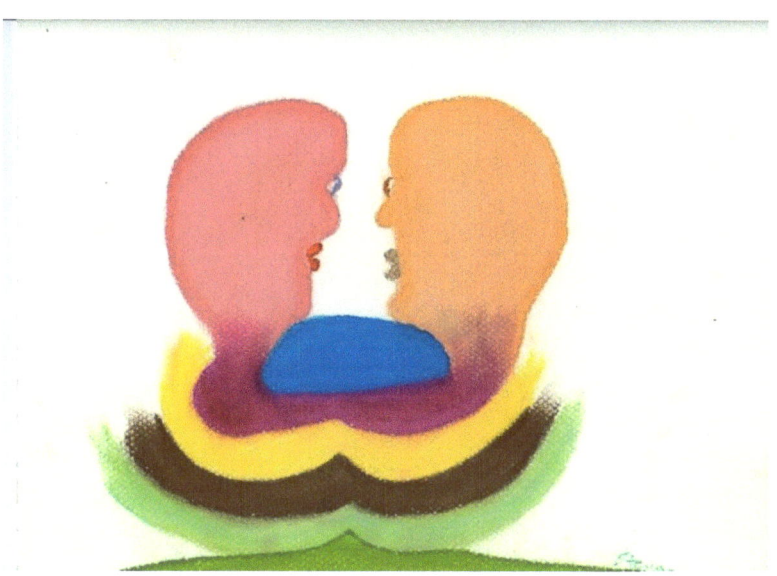

S

Life and Death

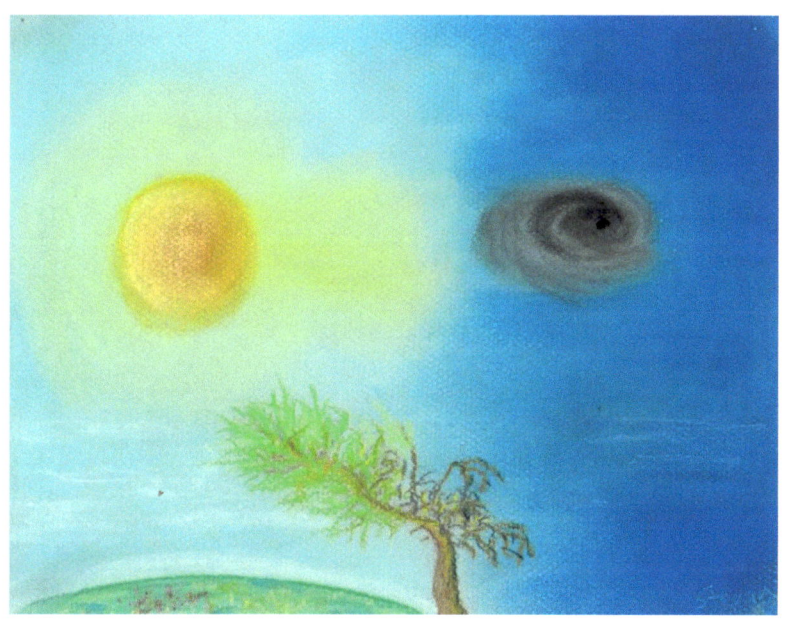

S

Time

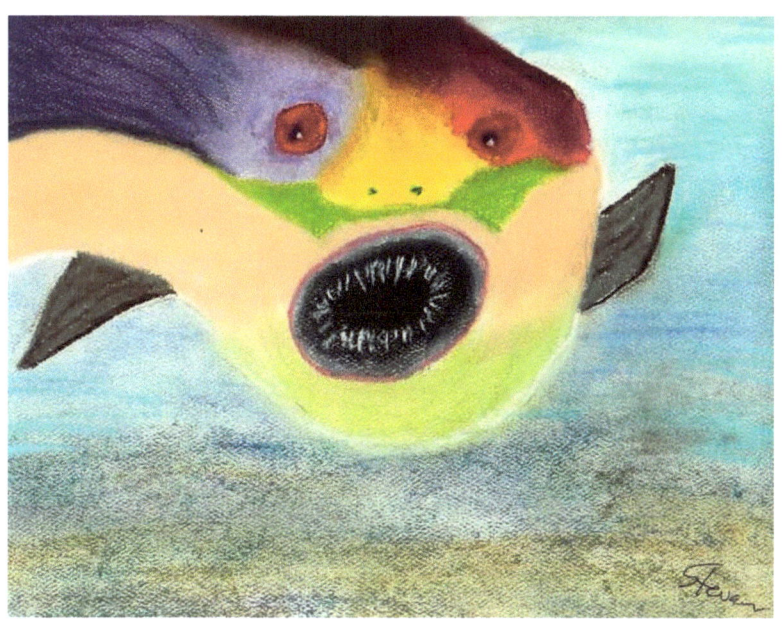

S

Black Hole

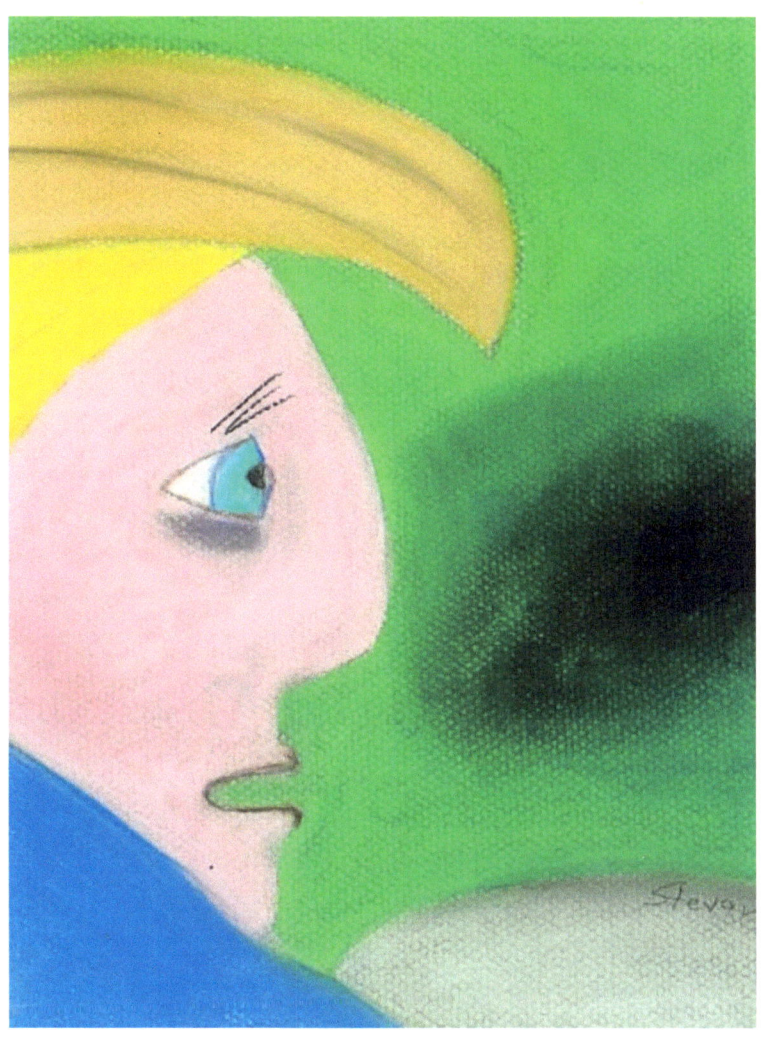

S

Cold Landscape

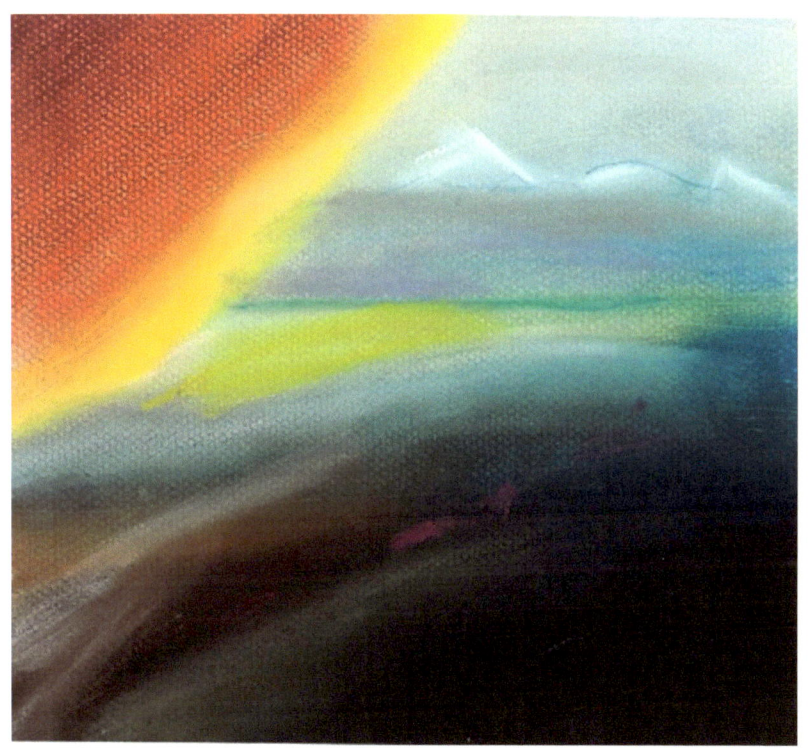

S

Simba

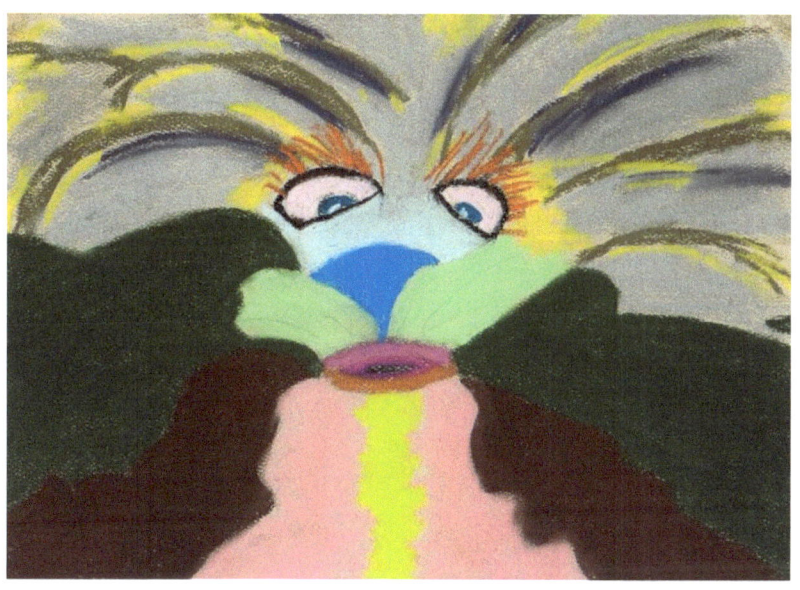

S

Floppy

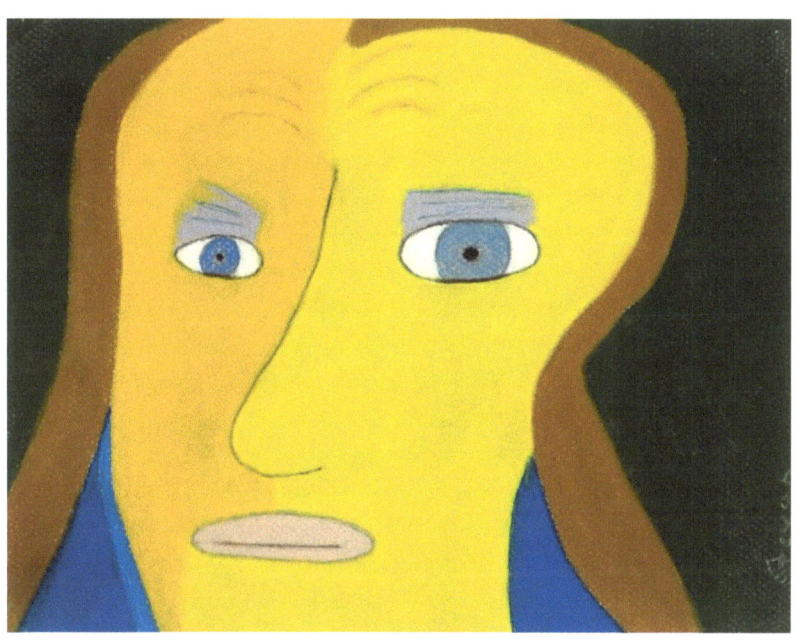

S

Masquerade

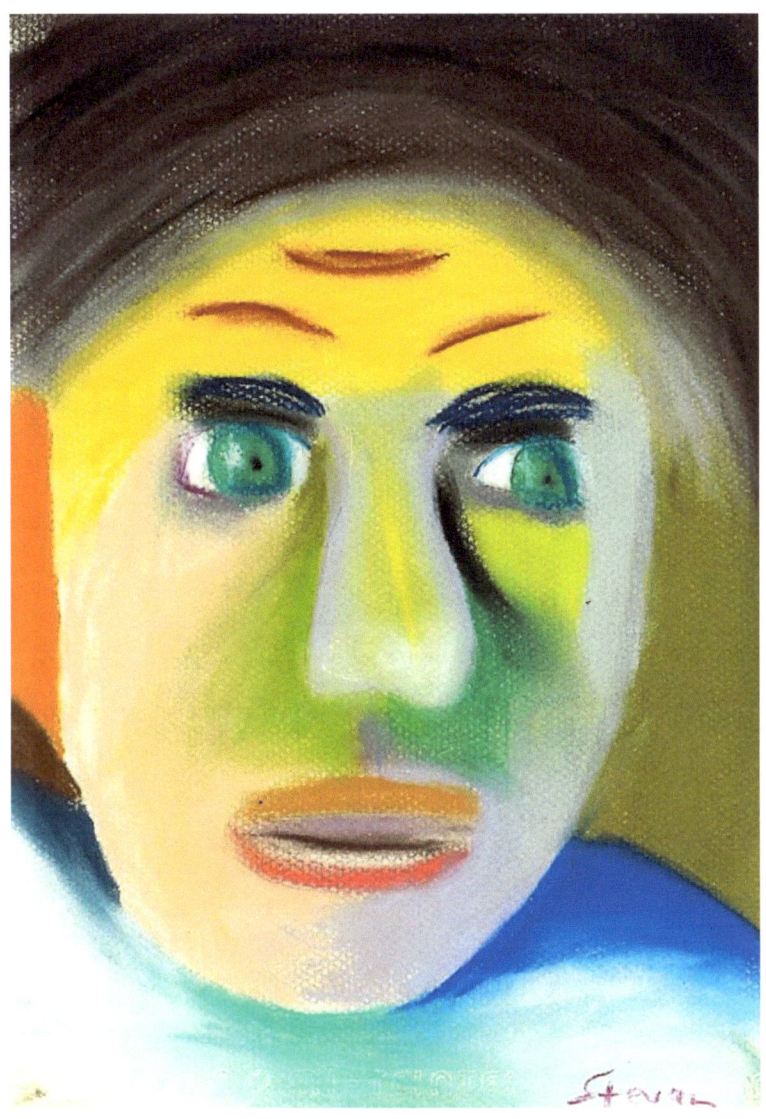

S

Smile

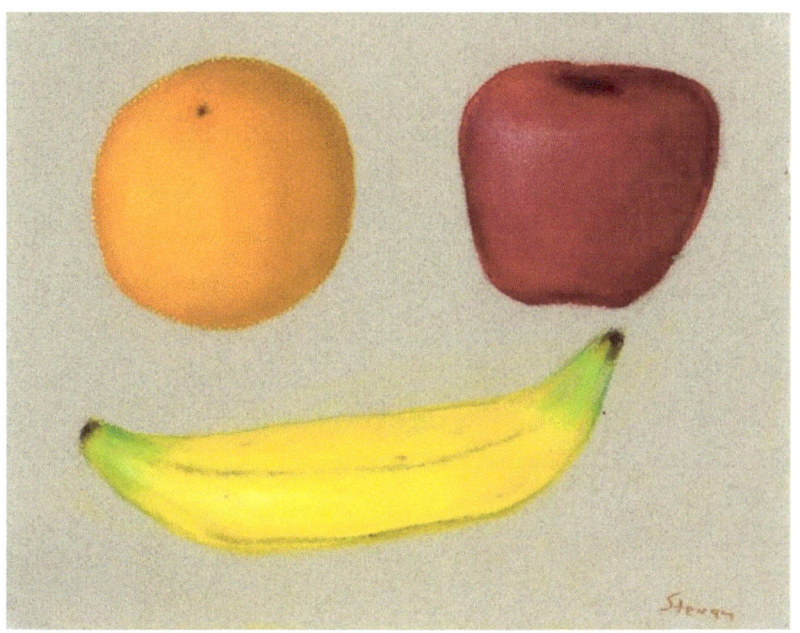

www.ingramcontent.com/pod-product-compliance
Lightning Source LLC
Chambersburg PA
CBHW041103180526
45172CB00001B/84